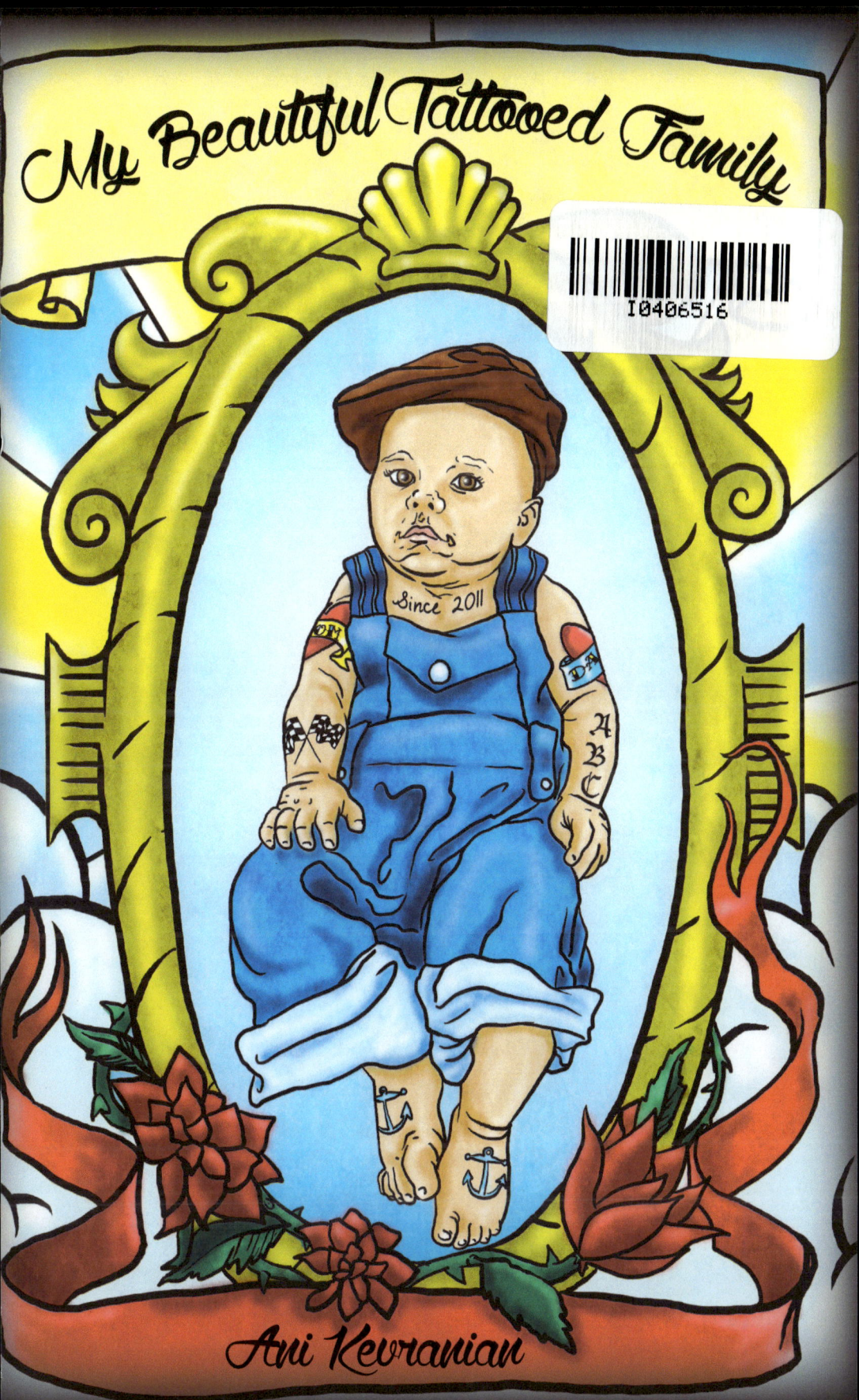

Copyright © 2014 Ani Kevranian
All rights reserved

ISBN: 1492713465
ISBN 13: 9781492713463
Library of Congress Control Number: 2014902761
CreateSpace Independent Publishing Platform
North Charleston, South Carolina

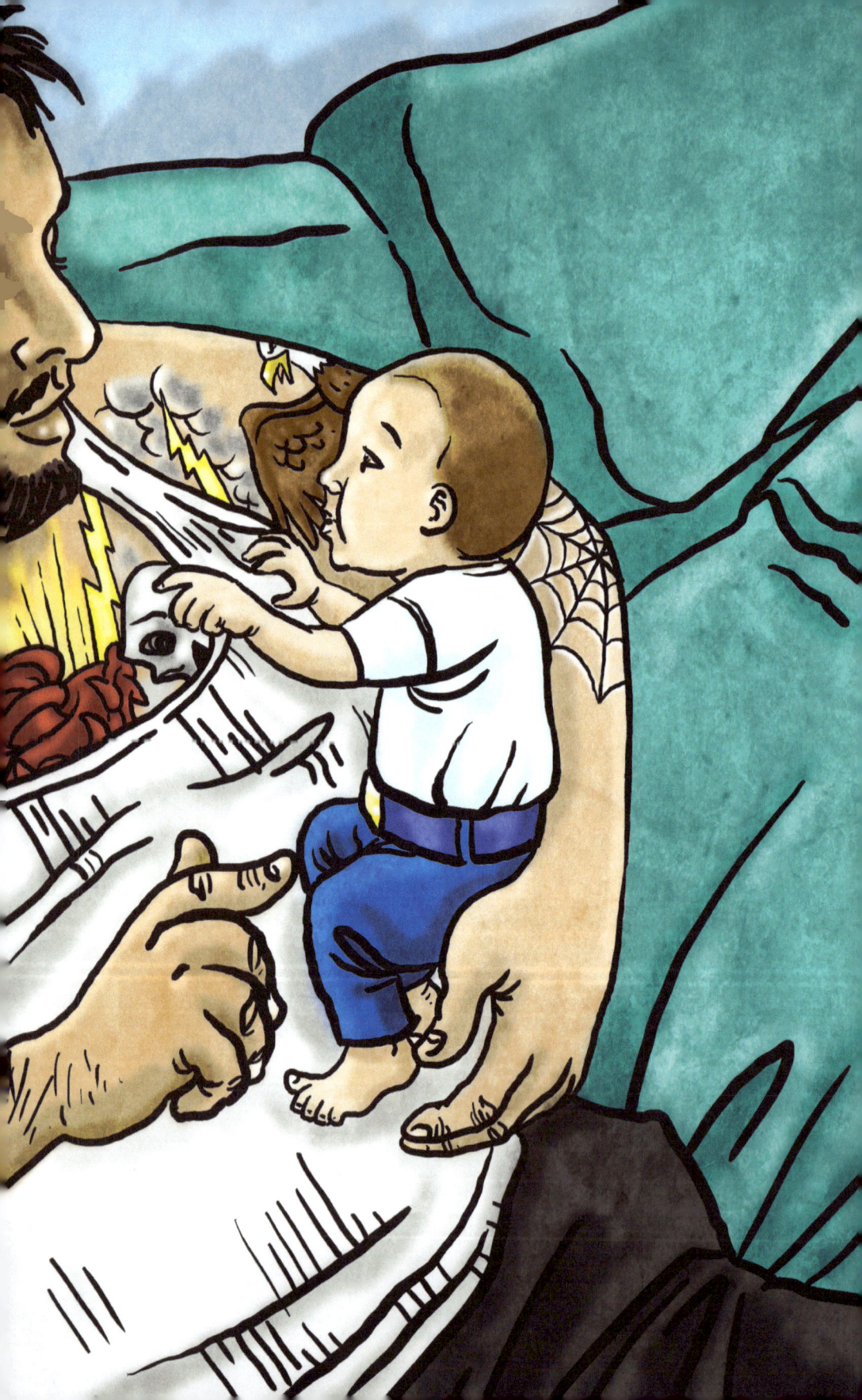

I have an awesome dad who has a lot of cool tattoos. Sometimes, the art on his chest seems to come alive. I stare at it and touch it to see what will happen. I realize his tattoos are permanent, they are not temporary, and they will not get scrubbed off during bath time. They are a part of my dad, and I love my dad and his beautiful tattoos.

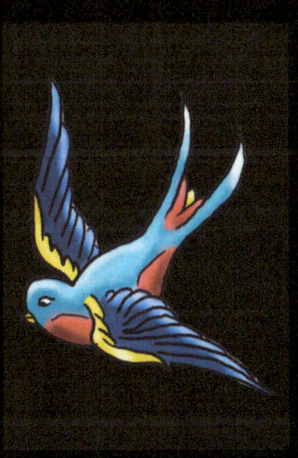

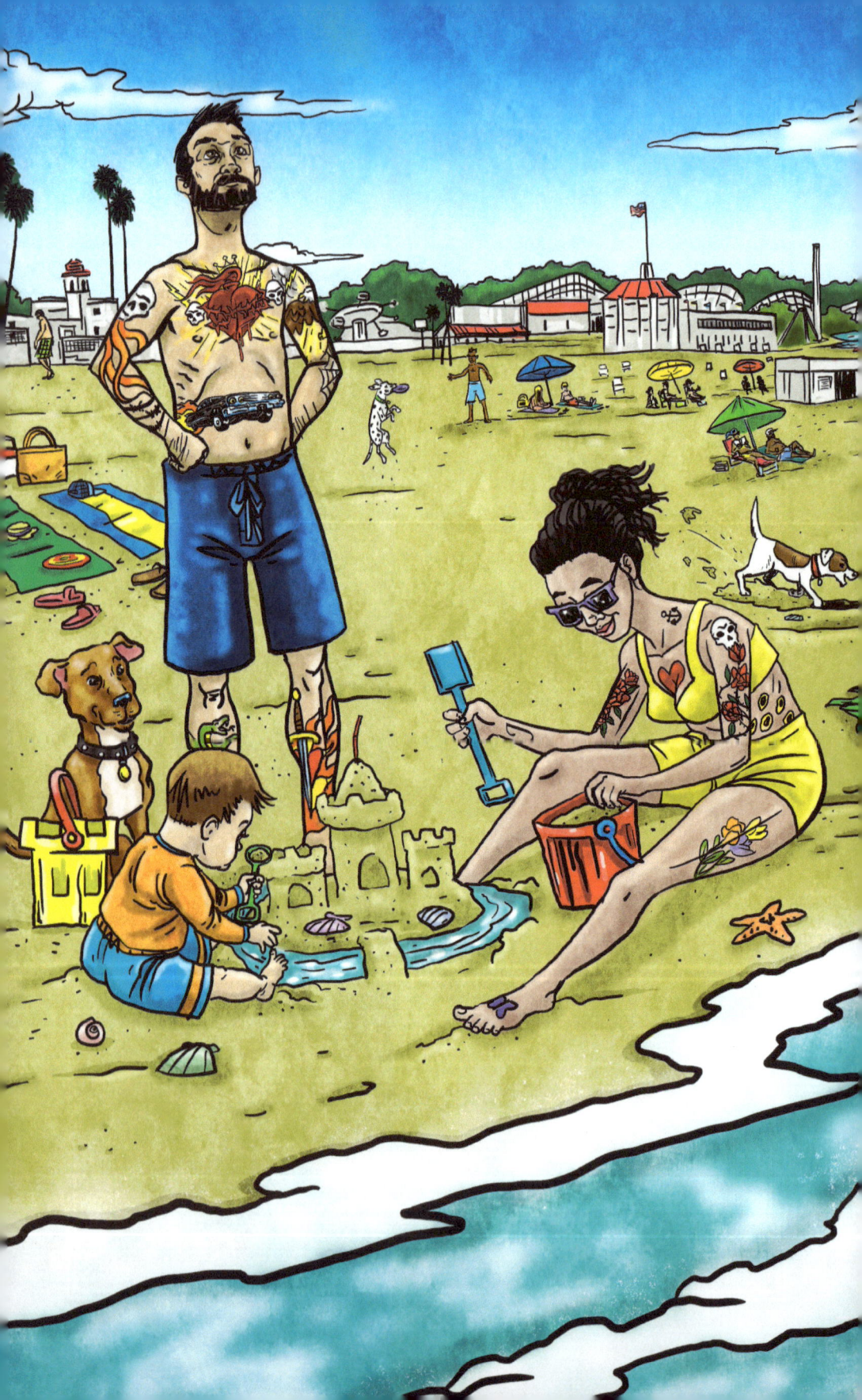

My mom is sweet and gentle. She has tattoos of anchors, ships, flowers, and a leopard patch on her back. She's a lovely mother who takes care of me like no other. I love my mamma and her beautiful tattoos.

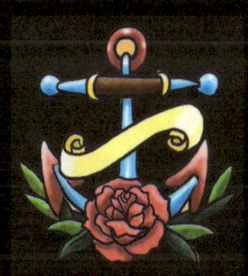

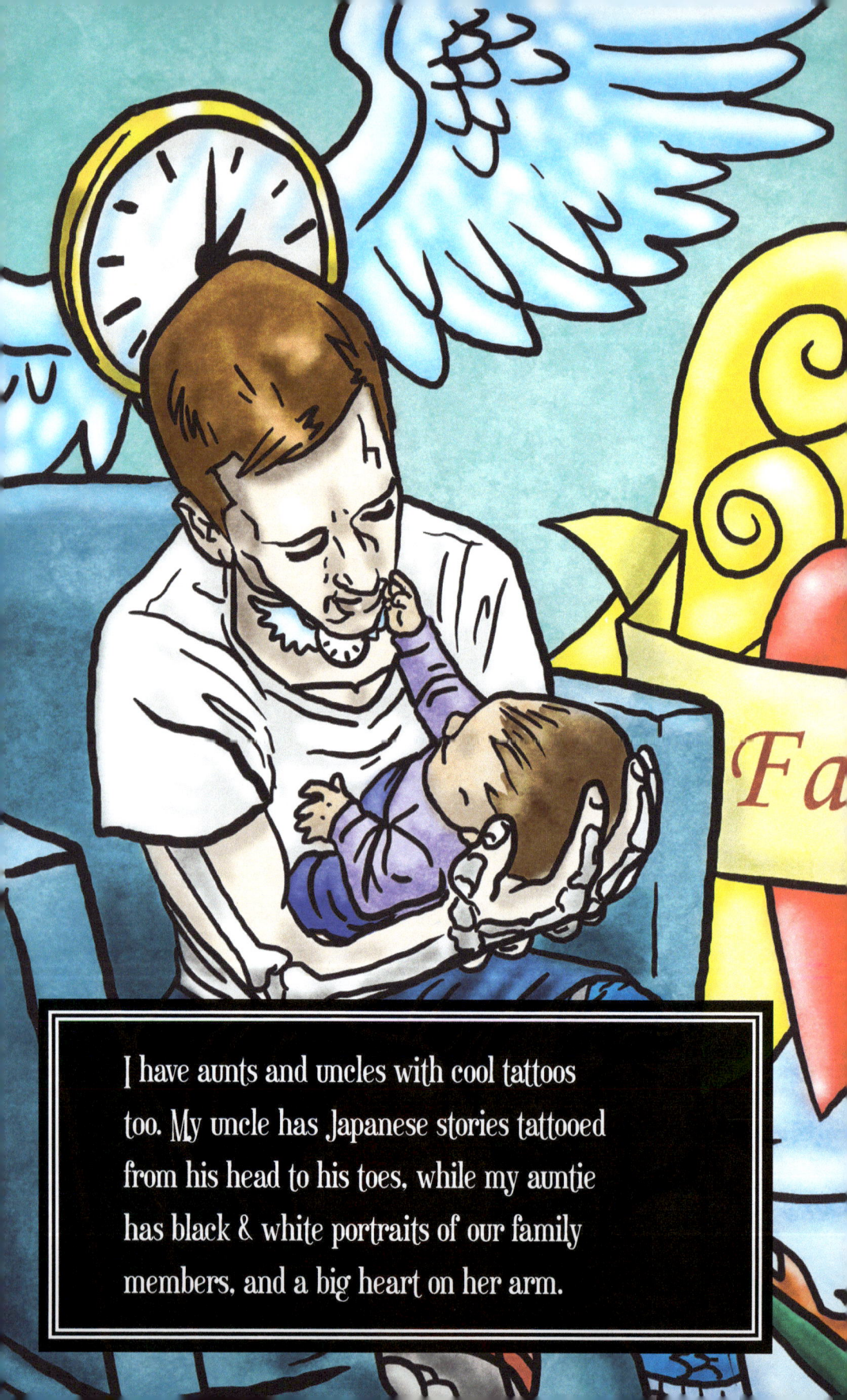

I have aunts and uncles with cool tattoos too. My uncle has Japanese stories tattooed from his head to his toes, while my auntie has black & white portraits of our family members, and a big heart on her arm.

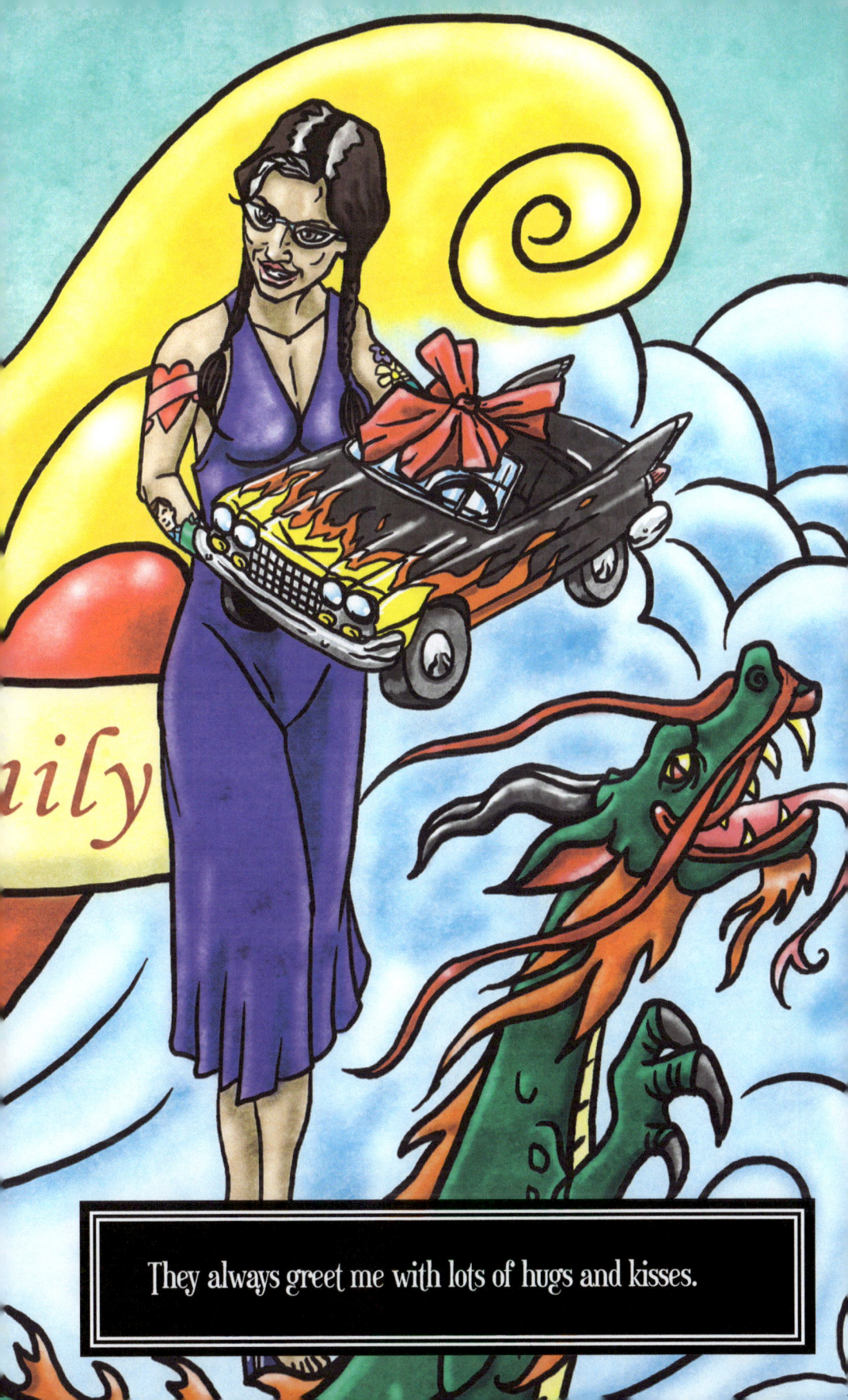

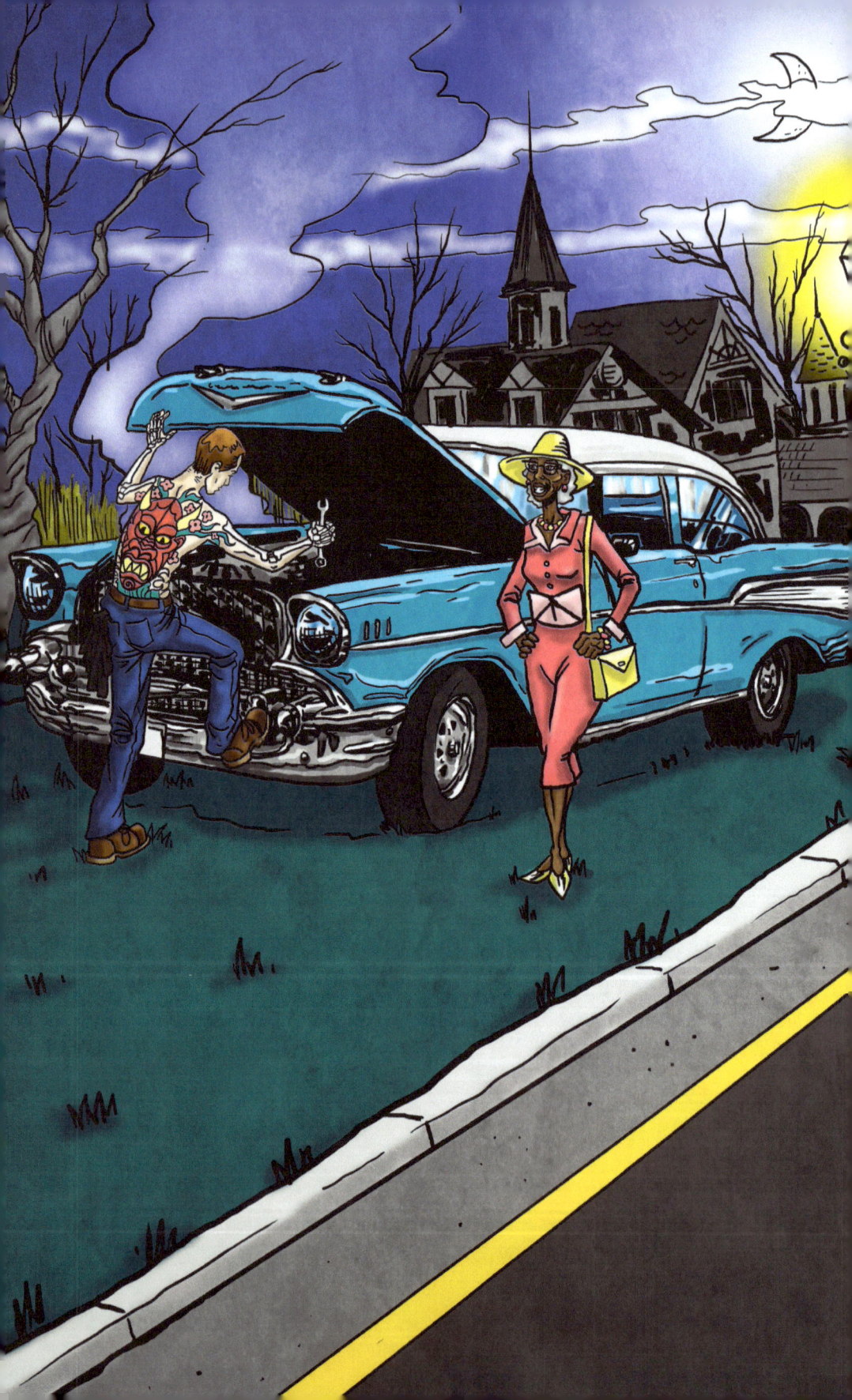

Some people seem afraid of my family, and judge them because of their tattoos. But I know how helpful, smart, and loving my parents and relatives are. I know that no one needs to be afraid of them, unless they mess with me, hehe!

My beautiful tattooed uncle is a mighty great person. One night, he stopped to help a nice lady with her broken down car. The lady was afraid of my uncle at first, but once she got to talk to him, she realized he just wanted to help. In the end, she was very grateful.

My family teaches me to help people out, when I know it's safe, and I think I can. And also, not to be so quick to judge people by what they look like. And instead, to be aware of my intuition, which is the feelings of love and fear I have about people or situations, on the inside of my body.

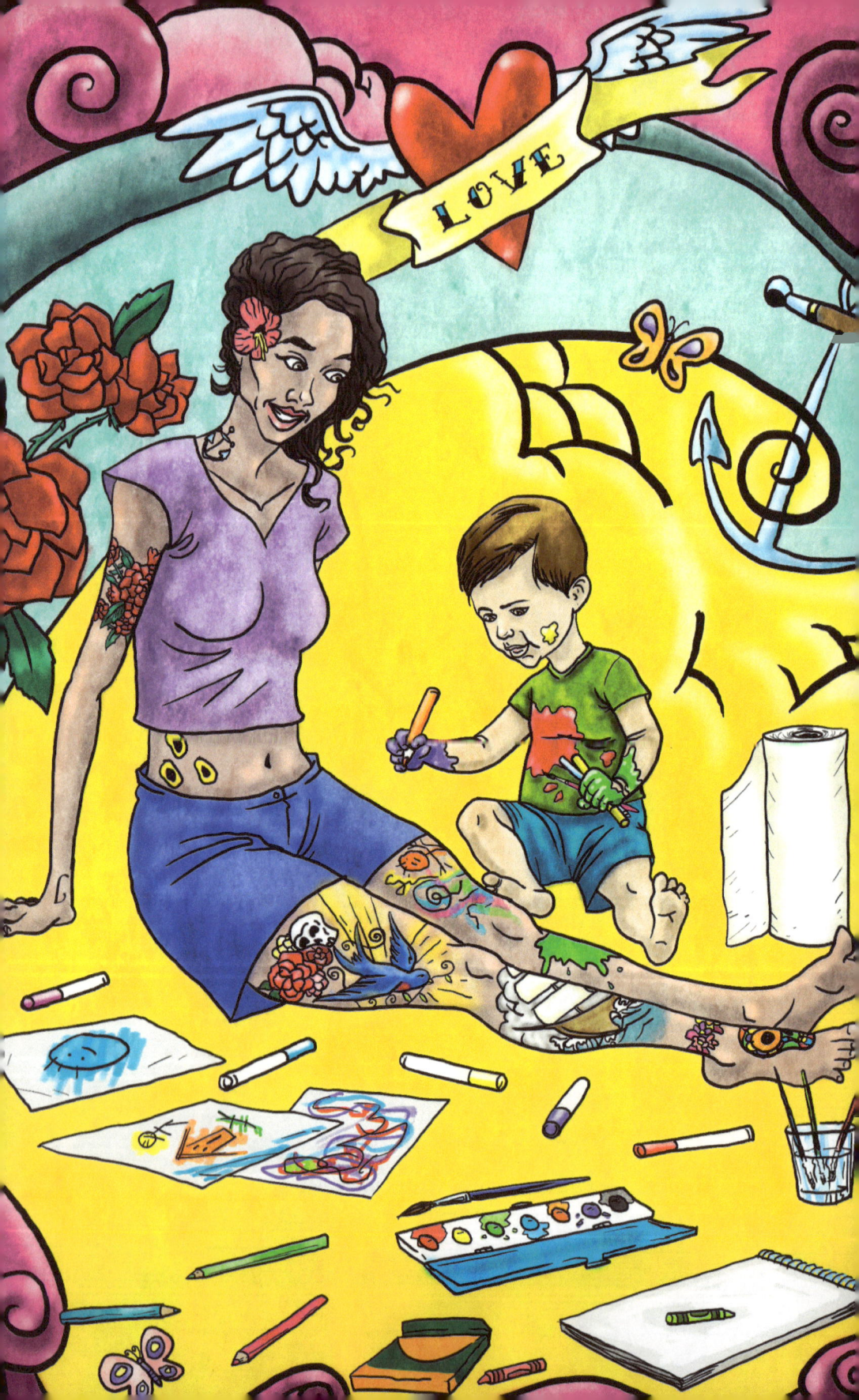

My family inspires me to never give up and to follow my heart. And everyday that the bright sun rises, I draw, because it makes me happy. I love drawing, and I will practice everyday so that I can become the very best at it. Sometimes, my mom lets me draw on her, and I pretend I'm giving her a tattoo. Maybe I can be a tattoo artist one day.

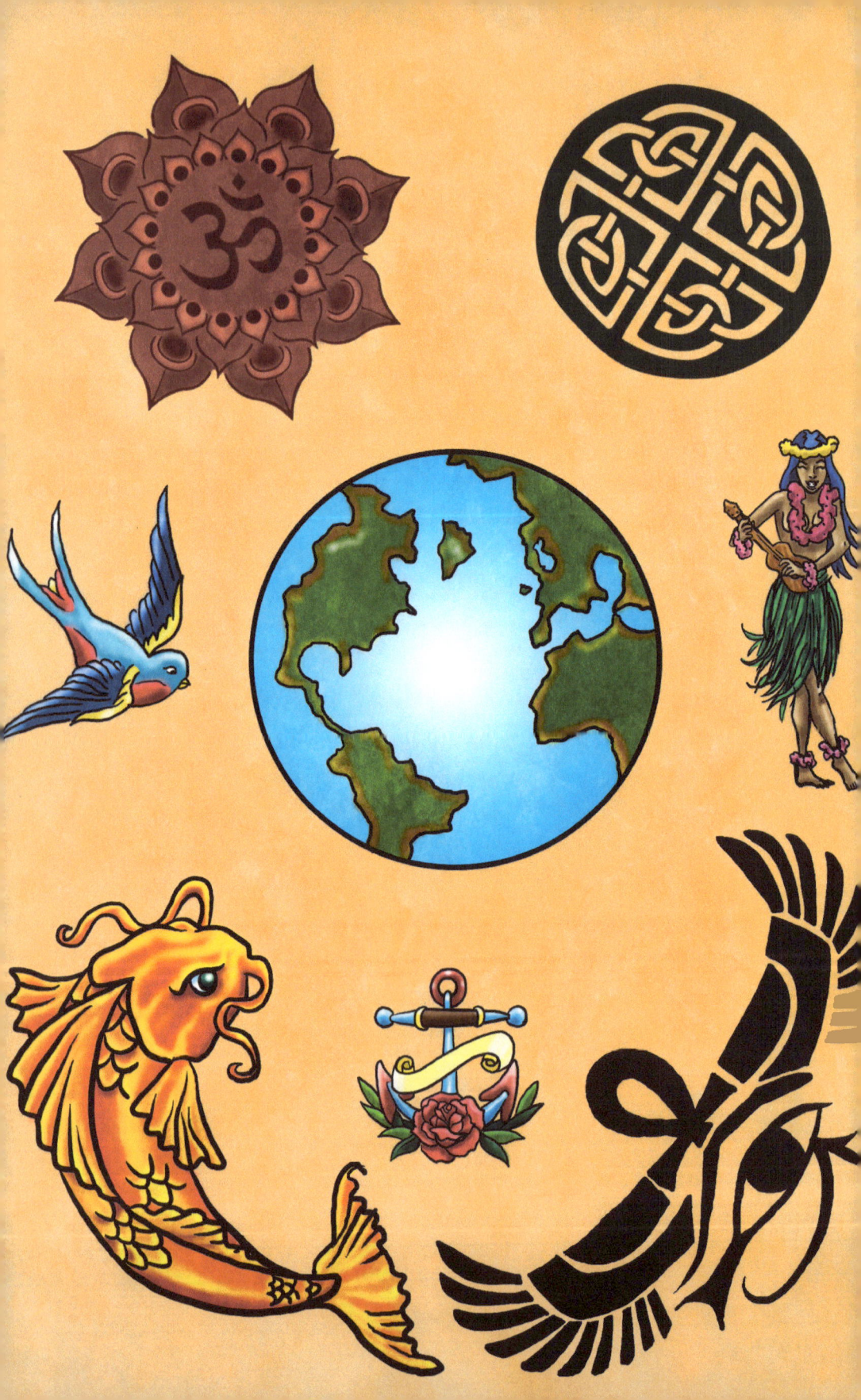

Art comes in many forms, and tattooing is one of them. Tattooing is a practice that involves using a special tool, which places colors of special ink deep into the layers of the skin, permanently. It's not easy to give or receive a real tattoo, and it's a big decision, so I'll make sure I'm an adult if and when I do.

Tattooing started a very, very long time ago. Many different cultures had their own styles and techniques. The Egyptians, Japanese, and Polynesians, are just some of the people around the world who started it. Tattooing has been around for centuries and is here to stay.

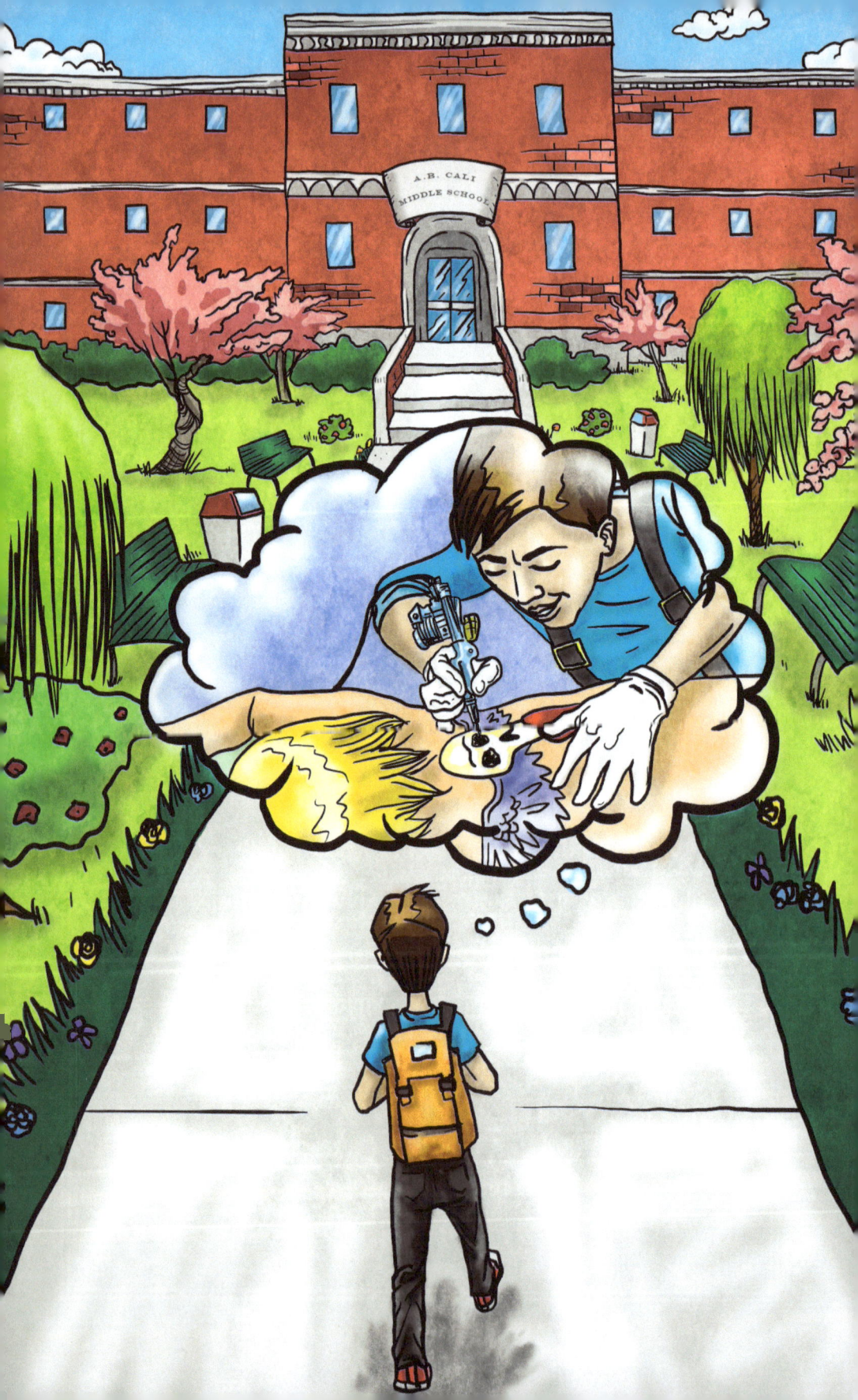

I enjoy going to school to learn about everything, but especially art. My family encourages me to make art and to be creative, and I love them for that, just as much as I love all their beautiful tattoos.

Create your own tattoos and art on this page.

Create your own tattoos and art on this page.

Create your own tattoos and art on this page.

Create your own tattoos and art on this page.

Create your own tattoos and art on this page.

Create your own tattoos and art on this page.

This book is dedicated to...

Garbis The Great

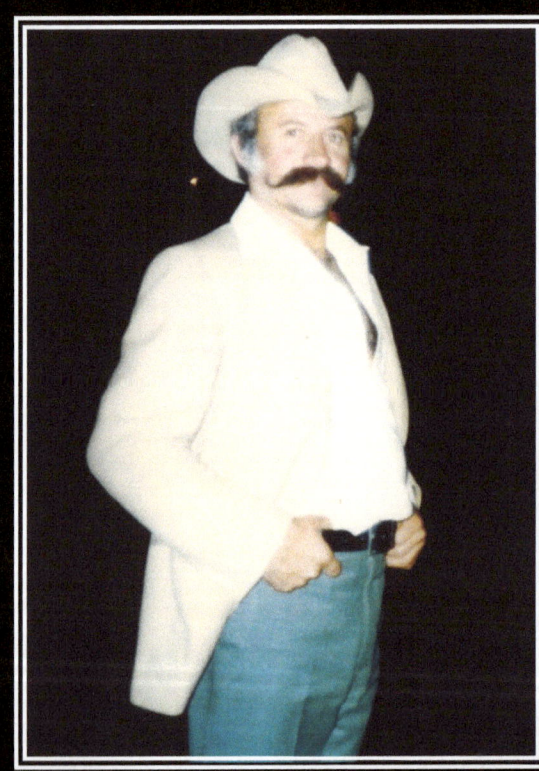

And for the love of tattoos

www.ingramcontent.com/pod-product-compliance
Lightning Source LLC
Chambersburg PA
CBHW040813200526
45159CB00022B/912